D0388084

MIXED MEDIA

When more than one medium is used to complete a painting it is referred to as "mixed media." This can be something as simple as pencil and watercolor, or it can involve several media such as acrylic, rice paper, ink and watercolor. In this book I have chosen to work with six different media combinations which are some of the most popular. The paints I have chosen are all water-soluble. This may be the trend because of convenience as well as their brilliance and the suitability of their working together. Much of the art in water-soluble material today is mixed media; however, mixed media is not a new idea. Artists have been mixing media since art first began as we know it. Each time a new media was introduced or discovered it was a challenge to use it along with other media already at hand. Part of the ongoing attraction for artists is the search for richer surfaces and personal expression. Continual experimenting will expand your knowledge and can be a most rewarding adventure.

This book will give you some guidelines to begin with. I hope it will also encourage you to complete a painting with whatever medium is necessary to make it an acceptable piece of art.

Thanks to my wife, Frances, for her patience and help.

CONTENTS

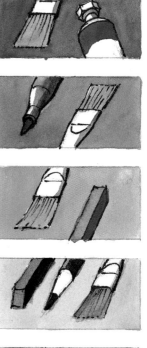
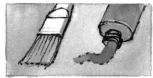

INTRODUCTION

In this book I will demonstrate six different approaches to a mixed media expression of subject matter, all sketched on location. I intend to show as much information as possible of how to arrive at the finished piece of art. I feel that it is the responsibility of each artist to present the very best finished painting possible for him or her, regardless of the means used to accomplish it. If it can be accomplished with one medium that's fine, but if you're not satisfied with the final product you should use every available means to improve it.

I recommend verbalizing more and painting less. By this, I mean to first think about what personal messages and feelings you wish to convey through the painting. What do you want to say? Evaluate your painting as you progress. Are you saying what you had intended? When you are finished, critique the painting again. Is it the best you can do? What can you change, if anything, to improve the painting? Can it be accomplished with the addition of another medium? Can it better express your inward concept? Does it enrich the surface? It is the obligation of the artist to be satisfied, as much as possible, with the final painting before revealing it to anyone. It is the measure of *you*.

Frank Lloyd Wright said, "In the world of visual arts, you expose who, what and where you are."

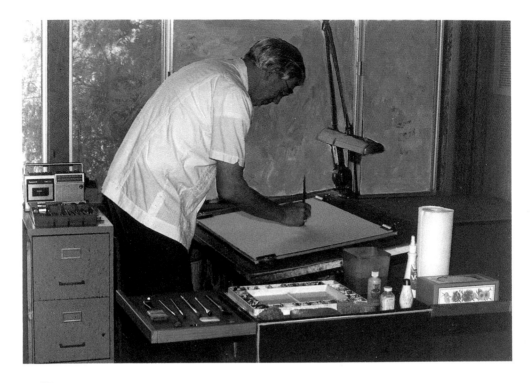

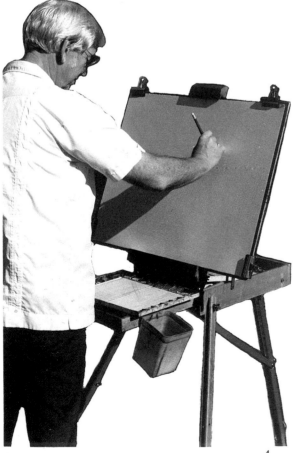

In my studio I use a drawing table tilted at 15 degrees. I can work standing or sitting; I prefer standing. A French easel is used for painting on location and painting vertically in the studio. I use it directly behind the drawing table (shown above) so I can work vertically or horizontally. It allows me to put a mat on my work in progress so I can stand back eight or ten feet to evaluate it. Working vertically allows for a more casual approach, and when standing, I can work over the entire surface at once and see what is happening. I have north light on my left and fluorescent light above the board for dark days or night work. I also have a ceiling fixture overhead. I try to keep a balanced light, as close to daylight as possible. On my right (being right-handed) is a taboret with rollers on which I keep my brushes, paint, water and all the other things I use while painting.

MATERIALS

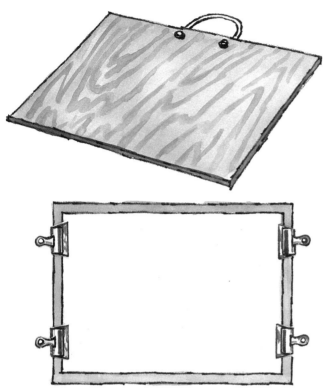

DRAWING BOARDS

A piece of 3/8″ plywood, sanded on the edges, works well for a drawing board. For easy transport, drill holes on one side and attach nylon cord handles. A good selection of sizes is 18″ x 24″, 20″ x 26″ and 24″ x 32″. You clamp the paper to the board with clips and are able to begin painting immediately. As the sheet expands from the moisture, simply loosen the clamps and stretch the paper until it stops expanding. The size of board to use depends on the size of paper. If using 22″ x 30″ paper (full sheet), use a 24″ x 32″ board with clamps on four sides. For a painting that will mat 18″ x 24″, use paper 20″ x 26″ and a 22″ x 28″ board. For a half-sheet (15″ x 22″) to mat at 14″ x 20″, use an 18″ x 24″ board. To use a quarter sheet (11″ x 15″) to mat at 10″ x 14″, use a 13″ x 17″ board.

PAPER

There is no substitute for quality when it comes to paper. The finest water-color paper is recommended. (You can always use the other side if you make a mistake.) There are three types of surfaces available; hot press, cold press, and rough. Experiment to see which kind you prefer. I use 140 lb. weight regularly, and 300 lb. for collage. Other surfaces you might want to try are illustration board and charcoal board.

CLIPS

Clips can be obtained in any art store. You will need at least four. I keep several in the studio and some with my traveling gear. The larger ones are easier to handle and hold the paper more securely than the smaller ones.

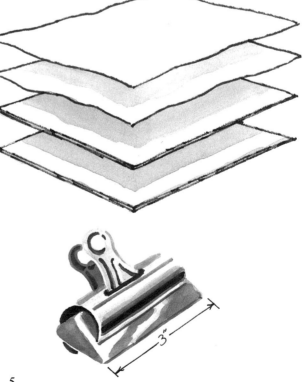

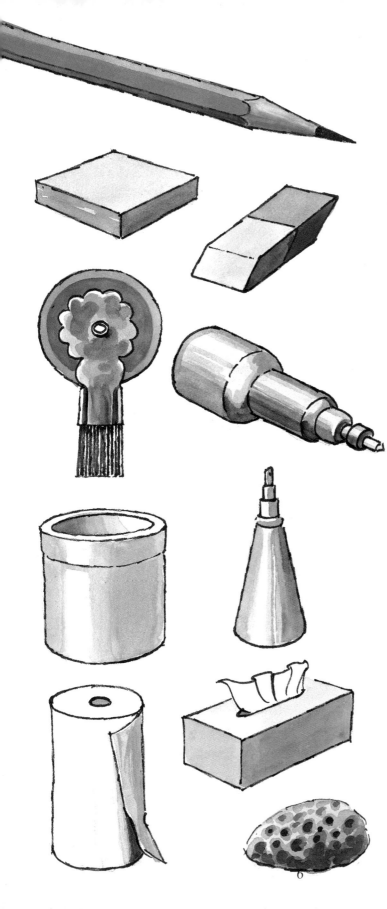

PENCILS

I use HB pencils for all drawing. They are soft enough to make lines that show through the first washes, and not so hard that they indent the paper surface.

ERASERS

A kneaded rubber eraser is ideal for lifting graphite. An ink eraser is also good as it will lighten a wash or lift out a line. (A typewriter eraser is even better.) For lifting soft or hard lines through washes, I use an electric eraser like the type draftsmen use. It goes down to the white paper readily, but if you're not careful it might go right through the paper. You should experiment with it before using it on a painting.

WATER CONTAINERS

Two water containers are needed. A ceramic crock is recommended for wetting and cleaning your brushes as you can swish your brushes vigorously without spilling. A plastic spray bottle filled with water is used to keep your paints moist and for spraying water into wet color to create texture.

PAPER TOWELS, PAPER TISSUES, and an assortment of man-made and natural **SPONGES** are good for lifting or for enhancing texture.

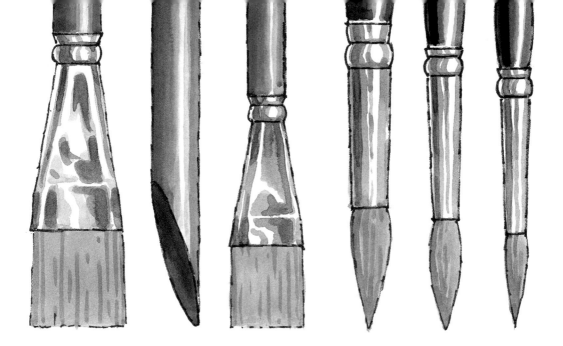

BRUSHES

An assortment of watercolor brushes will prove valuable. Buy the best ones you can afford. The new man-made fibers work well. I recommend at least a 1″ flat, 3/4″ flat, and no.'s 14, 10 and 8 round. A 2″ brush for either watercolor or gouache will be useful also. I also recommend a stiff 3/4″ brush for applying glue or acrylic media, and a no. 10 all-purpose round. A 1/4″ stencil brush works well for scrubbing out areas or lifting washes. A knife with a blade as you see here has many uses.

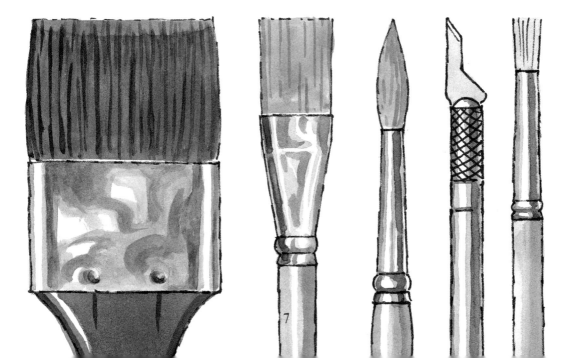

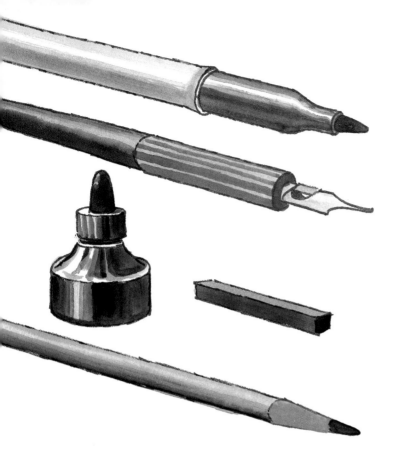

FELT PENS

I use a waterproof felt pen with a medium tip. There are several on the market. Try different types to test the "feel." I use black and brown.

INK PENS

I use a pen holder with an assortment of pen points for dipping in india ink. Black, waterproof india ink is recommended.

CHARCOAL

A charcoal pencil is probably the most useful type of charcoal. A stick of charcoal works well for broad areas.

PASTELS

You will need a set of at least 24 pastels to match your watercolors. You may also want to add some pastel pencils to your supply, especially white.

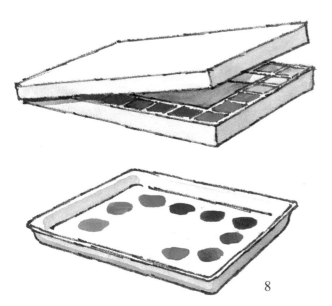

PALETTES

You will need a watercolor palette with a cover that is large enough for a good assortment of colors and has plenty of space for the paint and for working. For gouache and acrylics you can use a butcher's tray. Acrylics are especially hard to clean, so clean out the tray immediately after painting. An old scrap of matte board or a piece of plastic can also suffice as a palette, but be sure to work on a white surface.

PAINTS

Transparent watercolors in tubes are recommended as they are brilliant and easy on brushes. There are many brands on the market. If you decide to purchase the more expensive professional colors, buy the largest tubes available.

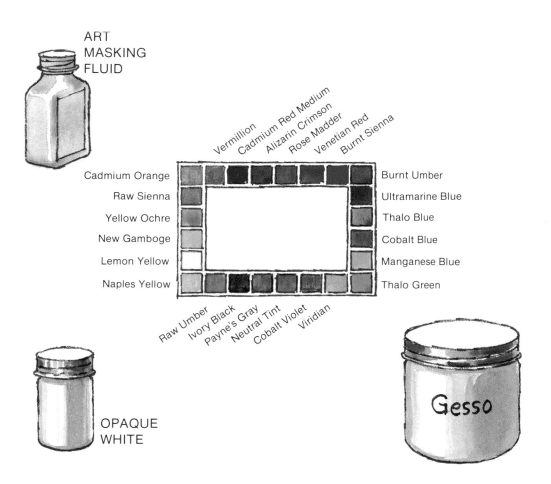

ART MASKING FLUID

Cadmium Orange
Raw Sienna
Yellow Ochre
New Gamboge
Lemon Yellow
Naples Yellow

Vermillion
Cadmium Red Medium
Alizarin Crimson
Rose Madder
Venetian Red
Burnt Sienna

Burnt Umber
Ultramarine Blue
Thalo Blue
Cobalt Blue
Manganese Blue
Thalo Green

Raw Umber
Ivory Black
Payne's Gray
Neutral Tint
Cobalt Violet
Viridian

OPAQUE WHITE

Gesso

GOUACHE

The difference between watercolor paints and gouache (pronounced "gwash") is that gouache has more pigment and less vehicle than watercolor. Chalk or something similar is added to gouache to give it more opacity, yet it remains water-soluble. The fact that light colors can be laid on top of dark colors gives it a very different character than watercolor. A limited palette for gouache is recommended unless you intend to use it often. A wide range of colors is available.

ACRYLICS

Both acrylic gesso and matte medium can be used for an opaque white. Each has qualities of its own. Experiment with them on scrap paper. They are permanent when dry. You can also use acrylic for ground for a textured base to work on. Use acrylic material to apply collage.

WATERCOLOR AND FELT PEN

Using the combination of watercolor and felt pen is an enjoyable undertaking. It can be accomplished in many ways, and the approaches are limited only to the artist's imagination — watercolor first and pen second, pen first and watercolor second, or a combination of these. This technique can be done on many different surfaces and if you use only waterproof pens you can wash over the pen lines as soon as the drawing is completed. Experiment with different felt pens and different surfaces. A high quality 140 lb. rough watercolor paper is good for this technique.

Move the pen rapidly over the paper surface, as if you were painting with a brush. The pen should hit only the tops of the rough paper, leaving whites in the nooks and crannies. This is where the watercolor wash will settle. The whites will give sparkle to your drawing, even in the darkest areas.

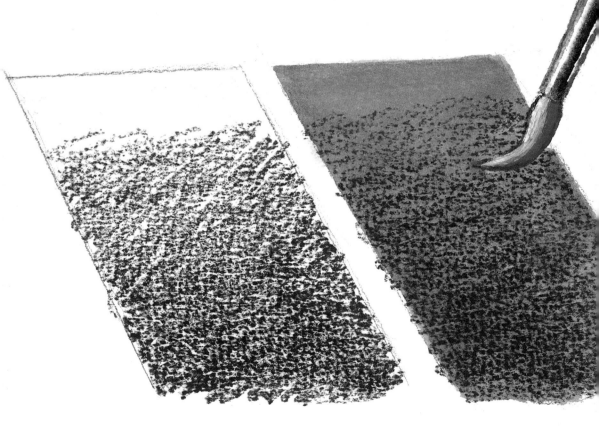

This example is actual size to show the texture of the pen on 140 lb. rough watercolor stock. Notice that the burnt umber transparent watercolor wash is the same value, but the light to dark is carried by the pen work.

1. It is recommended that you sketch on location for firsthand information. Many times the finished work can also be done on location. Your sketch should reveal the light source, the values and the shadows. Your *impression* is important. You can't achieve this in a photograph!

The drawing on rough watercolor paper must be done carefully because the pen is waterproof and not easily changed or erased. Consider your composition carefully before continuing. You might want to place a mat around your painting to evaluate it before you go on. This is the time to decide if the arrangement of the elements, the perspective and the proportions are to your satisfaction.

2. Using a felt pen on the parts of the subject that are closest to the viewer is a safe approach. This helps to prevent having lines accidentally running through solid objects. These lines are hard to erase.

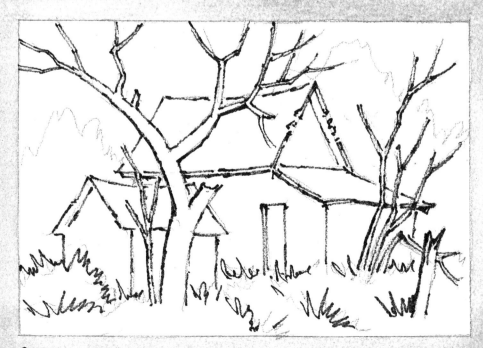

3. Here the outline is complete. It was handled a little rigidly, following the drawing carefully. Experience will allow you more freedom in these stages.

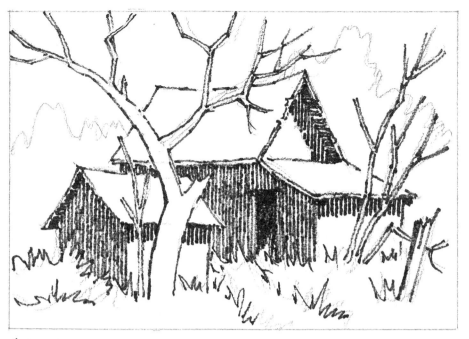

4. The light source was established in the original sketch, therefore, we can begin shading the sides that are away from the light and their accompanying cast shadows. Move rapidly so the blacks don't fill in.

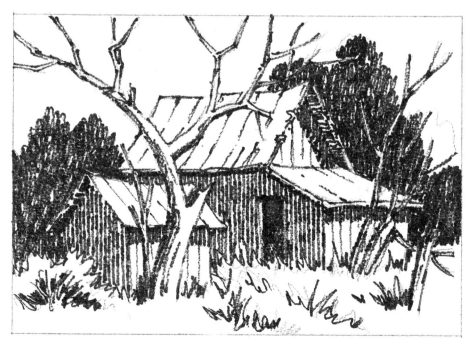

5. The final value drawing in felt pen is now ready for the watercolor washes. These drawings can be quite handsome and often sell at this stage. You will become more relaxed with experience.

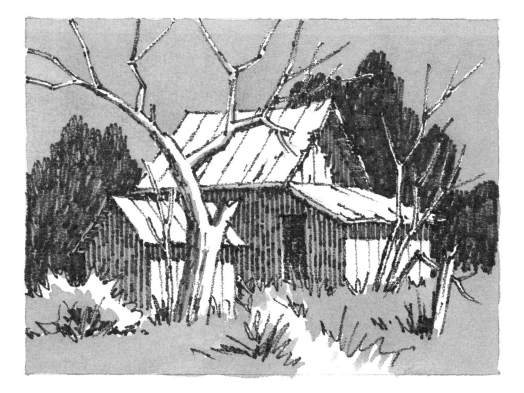

6. A color wash of burnt sienna (about a 30% value) is applied with a round brush and a flat brush. Change from one brush to the other as you move around objects. Leave whites according to your original sketch, but if in doubt, leave more than enough. The white pattern should be an exciting design in itself. The key to a successful result is walking in and moving about on a path of light, some small shapes, some large shapes, and some connecting lines and/or shapes.

Place a mat around your painting and evaluate it again. Do you have enough whites? If not, it's scrub-out time. Use an electric eraser or an ink eraser. Where will additional contrast help? This is planning for the final step.

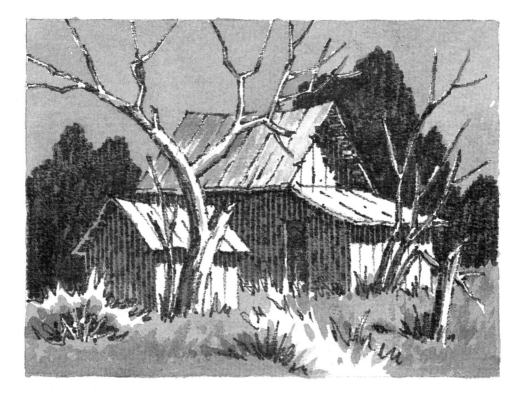

7. In this stage we will put "punch" in the painting. The final wash of burnt umber is now applied. In some areas it will be a light wash; in other areas it will be full strength. The burnt umber added to the dark brown ink of the pen and over the burnt sienna produces a very dark value. With this range of values we also have great control. Notice the light wash of burnt sienna used on the roof where there was too much white. Reducing some of the whites makes the remaining whites more precious. If you feel the need for more texture or separation at this time you can use the pen again, as much as necessary. You may also want to remove or reduce some of the strong lines on the right side.

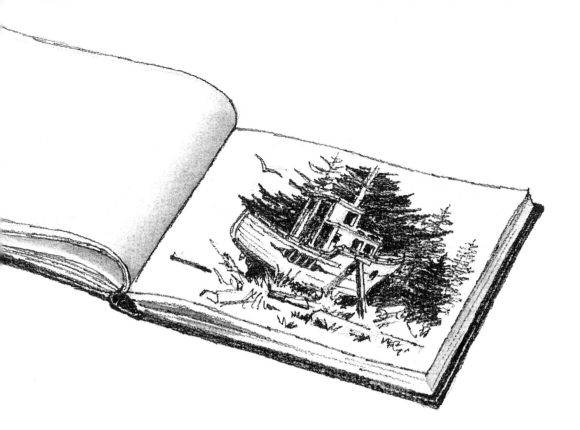

1. Using a sketch is preferable to using photographs or slides because a sketch will usually capture some of the feeling of the subject and the environment at the time. The human eye takes in much more than the camera. When you sketch, include whatever you feel is needed and omit those things which detract or seem unnecessary to convey your message. If time permits, walk around and make several sketches. Firsthand information, or information from being on the spot allows you to work with more confidence and authority.

A good sketchbook is an 8″ x 11″ hardbound book, bound on the side so the pages are about the same proportion as a horizontal painting. The paper should be of good enough quality to take pencil, pen and ink, felt pen and wash.

This sketch was done on San Juan Island, off the coast of Washington, using a water-proof felt pen. Using pen rather than pencil keeps you from over-detailing and forces you to make decisions on what and where. Final changes are made in the studio using the sketch, your memory (which is very important), and perhaps a photograph to remind you of a few key colors.

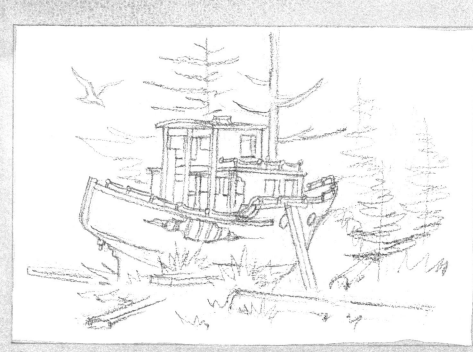

2. The pencil drawing is completed on rough watercolor paper. Make final adjustments to the position of objects in relation to one another and to the paper.

3. Felt pen is used on the objects closest to the viewer. Some things are left to be done with brush and paint. Working rapidly over the surface of the paper leaves a nice sparkle to the entire drawing.

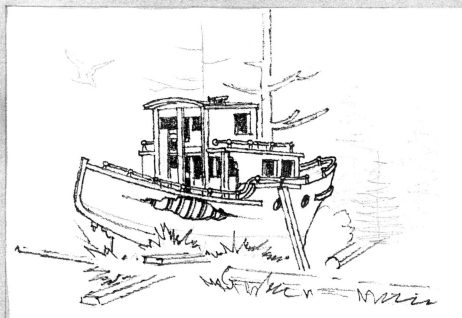

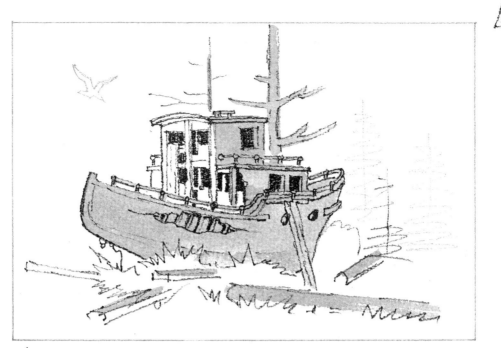

4. The light source has already been established in the sketchbook, so cover everything you want to leave white with art masking fluid. This is applied with a small pointed brush (do not use one of your good brushes). Be sure to clean your brush out immediately. Use rubber cement solvent or thinner to clean it if necessary.

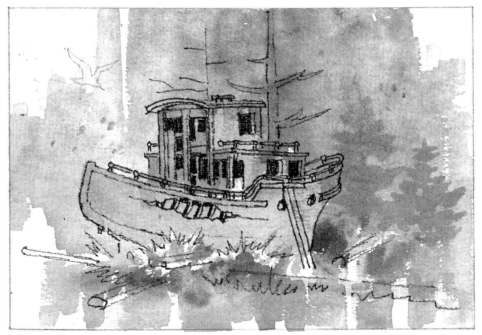

5. After the masking fluid is dry, a background wash is applied over everything. A few trees are indicated while the wash is still wet. The foreground is painted in with a lighter value of the color you want it to be in the final painting. If the color is not too intense at this time, you can change your mind later.

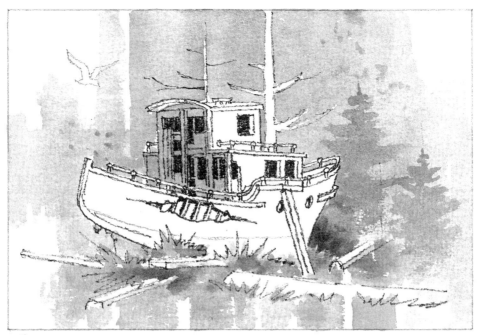

6. When the wash is completely dry, the masking fluid can be removed with a rubber cement pick-up (available at any art store) or by rubbing it with your fingers. Whatever you use should be dry so the watercolor doesn't smudge.

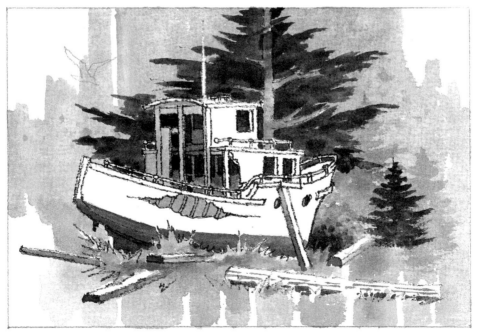

7. Now the shade and the shadows on the subject are washed on. Then the background is painted with values dark enough to emphasize the boat and to create a feeling of depth. Some foreground detail is also begun. Remember — light against dark and warm against cold.

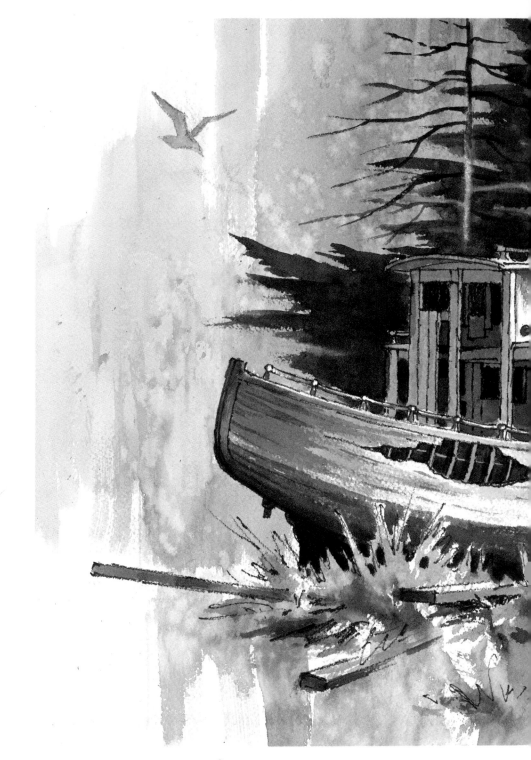

8. Now for the fun part! Add the final details, emphasizing the wear and tear. This is where character and mood come together. Again, mat the painting and evaluate. What can you do to improve

it? One of the dangers is to overdo it. Sometimes less
is better. Put the mat on and set it up for viewing.
Take a break for awhile, then come back and view it
with a fresh eye.

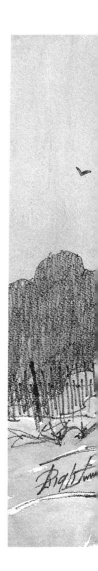

**YELLOW
OCHRE**

**BURNT
SIENNA**

**THALO
BLUE**

Pencil

Felt Pen

Transparent Watercolor

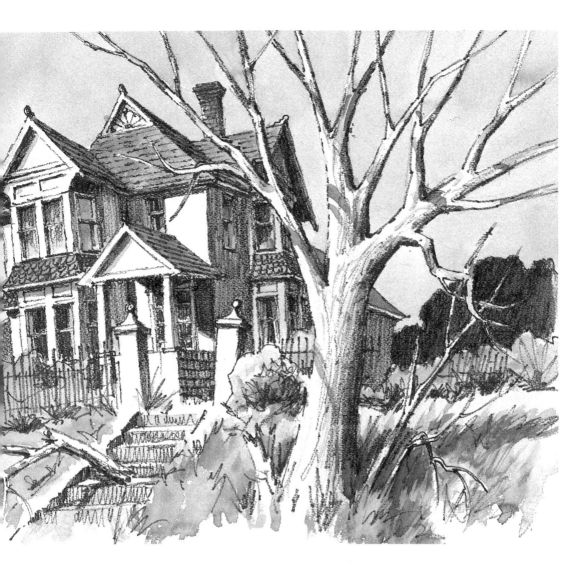

Here the entire process can be seen at a glance. The pencil drawing is done first on rough watercolor paper. This is followed with felt pen in the foreground. The watercolors used are yellow ochre, burnt sienna, and thalo blue. They are applied in that order, working from warm to cool. The sky is a combination of all these. A good sense of light and shade and a dramatic angle make this painting easy to read. The final result is quickly achieved with practice, giving a feel for the area and/or activity. A similar approach is very popular with great artists like Rex Brandt. An example of Mr. Brandt's work is in the Gallery section of this book.

WATERCOLOR AND PASTEL

Many watercolorists finish their paintings with pastels. This is probably natural since pastels are the purest form of pigment and can be applied over watercolor easily with great success in bringing out texture or rubbed in for subtle changes of color and/or value. Experimenting with this combination can be very rewarding. You should try several approaches. Using pastels can often save a sagging painting, but this is not the ideal reason for using them. *Plan* to use this combination. Experiment and practice, then when you have an idea of what result can be accomplished, you can begin painting with confidence. Remember, the final painting is the important thing, regardless of how you arrive at it.

A textured paper was used for the demonstration above. There are many papers available, but a 140 lb. rough watercolor paper is recommended. A light touch is used for texture. For darker values or more intense colors, bear down harder. For a more intense feeling, smudge it with your finger. On the right, watercolor washes were applied in the shapes of trees and bushes. When dry, the technique at the left was used over the watercolor to enhance the texture.

A pen drawing of an old Victorian house near Riverside, California is the subject for this demonstration. As is always the case on a sunny day, the light and shade are determined by the sun. The drawing is casual with just enough detail to bring out the character of the building. In the original sketch I stayed close to the proportions of the subject. These can be diminished or exaggerated later in the studio.

1. The surrounding area was slightly sterile, so in the final sketch I changed it to a California setting. There were eucalyptus trees in a field in front of the house and the San Bernardino Mountains were in the background so I included them. The fence was in a lot across the street, so I borrowed it to lend atmosphere to the painting.

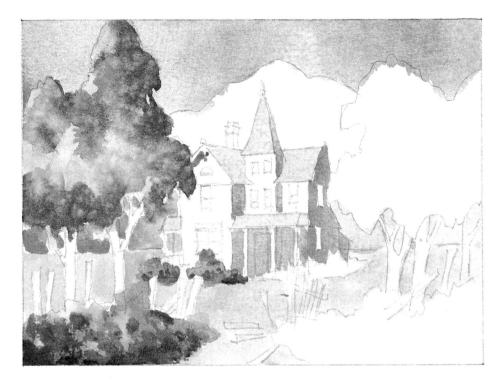

2. The watercolor is begun in a conventional way with washes of blue on the sky and on the shaded sides of the house. The warm foreground and the surrounding area is washed in with a warm color. The trees and bushes are handled much the same way. First, a wash which is the color of the lightest area of the tree in sunlight is applied over the entire tree and/or bush, determining the shape and the edge of the foliage. Then while it is still wet, other colors (working from warm to cool) are washed in (try not to destroy all of the original warm color). The light (sun) and dark (shade and shadow) of the vegetation is also created with these washes. If the first wash is allowed to dry, the result will be more detailed and less impressionistic. The basic colors used here are cobalt blue, yellow ochre and alizarin crimson. The green in the roof is a light value of yellow and blue mixed together. This can be worked over later.

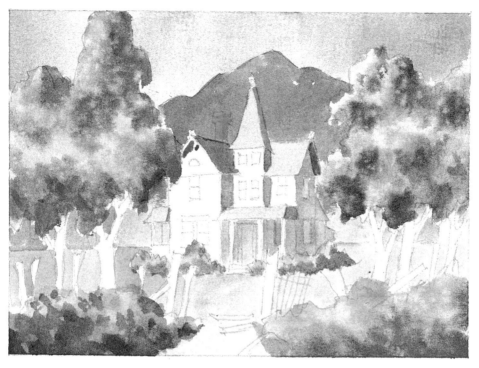

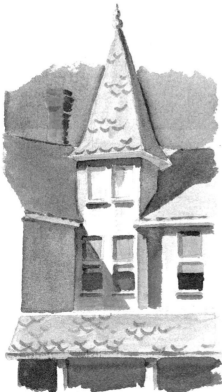

3. The washes that establish the color (mood) using both warm and cool and value (dark and light) have been completed. We now have basic shapes, so this is the time to consider detail. How much and where? Shadows are great for explaining shapes, pulling things together and providing an exciting dark pattern. Look for them when on location and invent them when necessary. Be bold in their application. Intensify color where you feel it should be stronger. I have added thalo blue at this stage. The blue and alizarin crimson make a good violet color for the mountains. Using the thalo blue and yellow ochre, we have a more intense green for the shadow and shaded side of the roof. If this is too raw, a little red can be added to gray it. The red is vermillion. It is used in the chimney, in the window and in some of the vegetation.

27

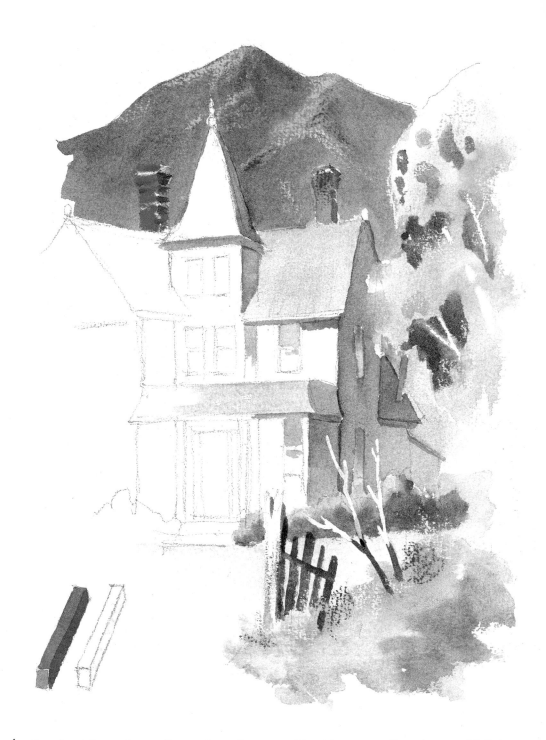

4. Pastel sticks and pencils work well. Sharpen the sticks to a wedge on one end to make sharp lines (this can be done on sandpaper). In this demonstration you can see how the shapeless mountain is given character and texture with a little work with pastel. The trees and bushes come alive and sparkle with texture. Experiment with light over dark. This works best on a rough surface if you are striving for texture. Remember, texture, like everything else, should be done with enough constraint that it is not overpowering.

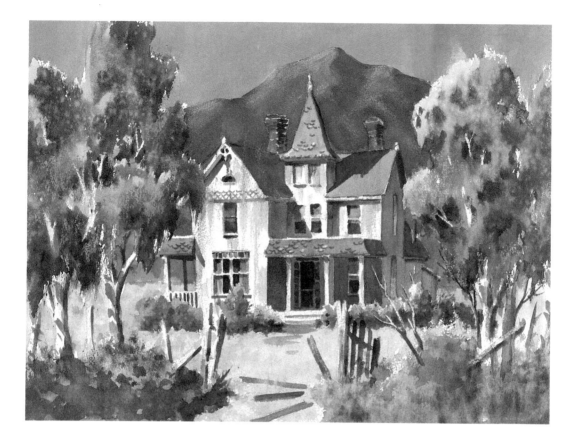

5. Finishing The Painting

A white mat is a great help when looking at the painting in a near-finished state. It excludes the rest of the surroundings so you can evaluate just the painting. Pastels were used in many places to complete this painting. The mountains and the trees needed a good dose of sunlight and additional texture. Pastels were used in the foreground, on the fenceposts and on the building to bring everything together. Try to achieve a feeling of belonging and an overall color harmony. Experiment to find out where you can go back in with additional watercolor washes and how compatible they are with the pastels that are already there. You may want to try a light coat of workable fixative at this stage. Do this carefully as it may have a dissolving effect on the pastels and if it is too heavy it will not take paint again very readily. Make sure that the painting "holds together." There should be variations of color without any being too dominant. Squint to see if there is any color or value that jumps out, especially in isolated places.

WATERCOLOR AND CHARCOAL

Charcoal may possibly be the oldest medium around today. It is enjoyable to work with as it gives quick results and can be used spontaneously. It is sometimes used for drawing on canvas for oil paintings and some watercolor artists use a light charcoal outline to work from. In this book we will use it in conjunction with watercolor and treat it as an equal medium. Use charcoal board as it has texture and takes both charcoal and watercolor well. Like all combinations of media, experiment continually. The final result is what is important, so try to enjoy some discovery every time.

One of the oldest methods of working with charcoal is to do the entire drawing first as in this example. Then a light fixative is sprayed over the drawing. After this has dried, washes are added in transparent watercolor.

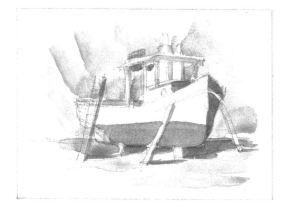

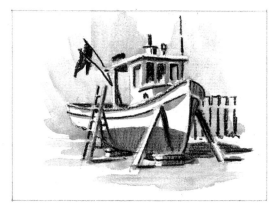

In this book we will do the watercolor first, leaving whites in the subject, the foreground and the background; then come in with the charcoal and define shapes, and add shade and shadow. Use a light amount of workable fixative, then come in again with final watercolor work, adding darker values and shadows.

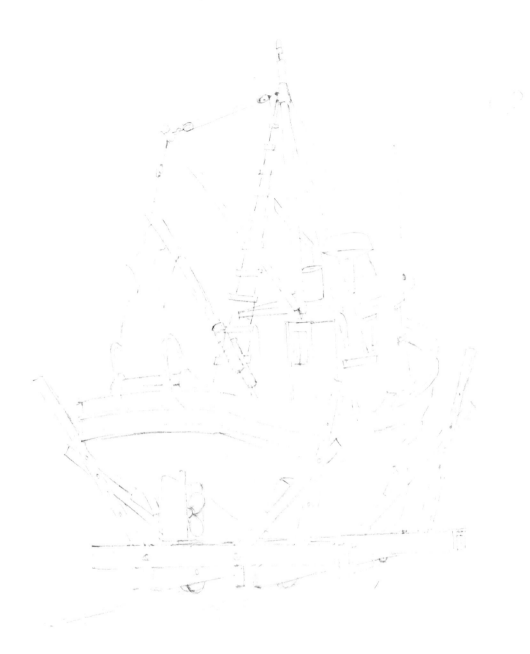

1. Using an HB pencil, lightly draw the subject on charcoal board. Charcoal board has a texture, but will take both charcoal and watercolor well (this is important). This is a commercial fishing boat in the Port of Los Angeles, California. Try to simplify a subject like this, but also keep it acceptable as a boat. Check the proportions and edit the rigging. The source of light is shown in the upper right. This will simplify giving form to the drawing. Now put a mat on the drawing to be sure the arrangement is the way you want it before continuing. A bad drawing will not make a good painting. Make any changes necessary. Continue only when you are sure that you cannot improve the drawing. Don't be a slave to the subject, move things around until you are satisfied. Add things that will increase the flavor without looking staged or awkward.

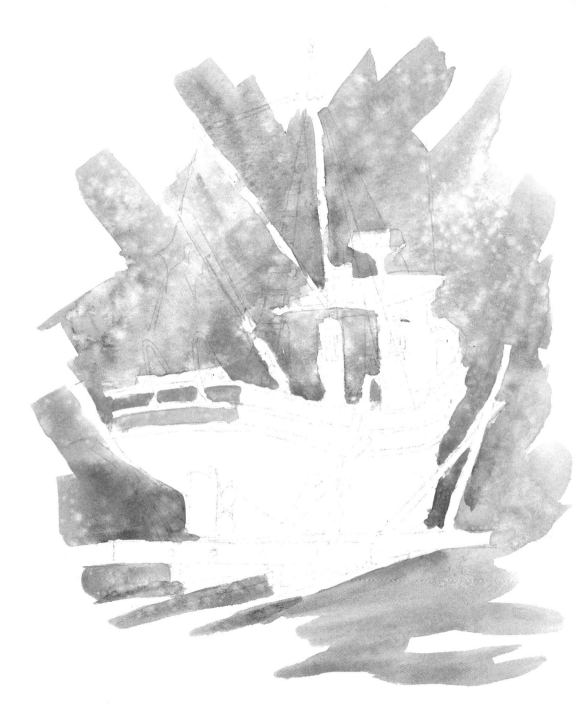

2. Since this was a bright and sunny day, apply some washes that will indicate that type of atmosphere. Although the color seems casual, it focuses on the boat. Leaving a few more whites than necessary is a good idea at this stage. It's easy to cover whites later, but difficult to retrieve them. Use an electric eraser to restore whites or to bring out certain lines or areas, but only after testing the eraser on the same type of paper or board that you are working on. (This is one reason for buying quality material to work on). Spray some water in the color while it is still wet. Try exaggerating this and the shapes of the color to experiment with this combination of media.

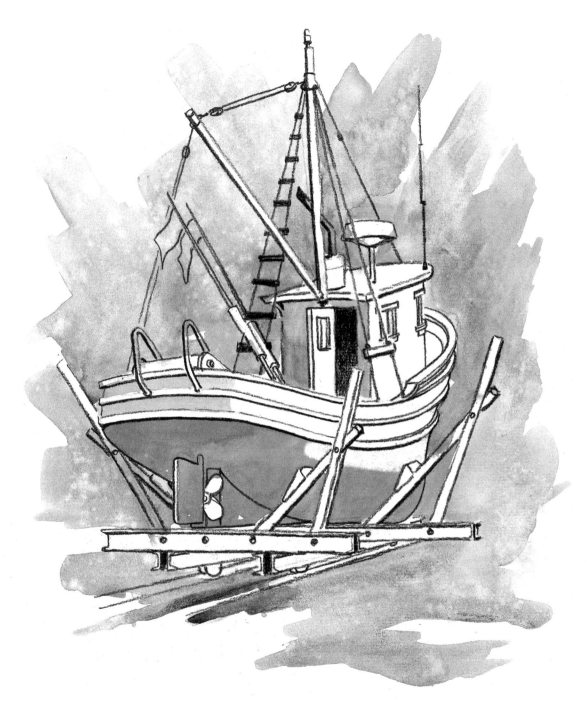

3. Now, using a charcoal pencil, begin defining the things you want to bring out in the painting. Keep in mind the direction of light (upper right) and put a heavier line on the shade side of the mast and the boom and under the eave of the house. The door is darkened in, and the necessary rigging is indicated. Put a wash of light red on the hull to indicate color and shape, and to define the area. This is an undercoat and will be left as is only where the highlight appears on the curve of the hull. The outlining is also completed here. Put on a light coat of workable fixative at this stage.

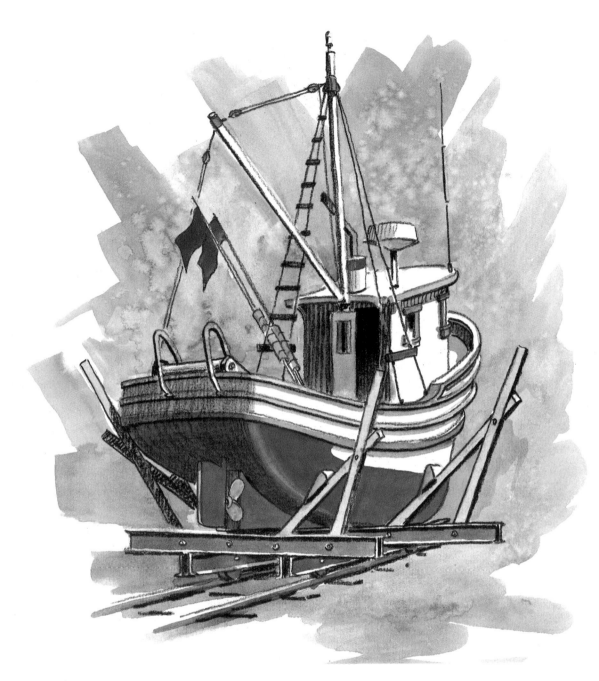

4. Now go back in with the charcoal pencil. Starting at the top, begin looking at shapes and defining shadows. The radar unit, for instance, is white. It needs shape on the left side and shade and shadow underneath. Apply the red trim on top of the stack. Then the areas away from the light — the house with the door open, the stern and underside of the hull — are worked over with charcoal and watercolor. The cradle the boat is sitting on is painted with rusts and neutral grays. Some cast shadows on the supports on the left should also be indicated. The screw (or propeller) is bronze and is painted with a base color now. The color for the flags and the floats can be decided now. Step back and take a look. The subject should be taking over while the washes in the background become subordinate.

34

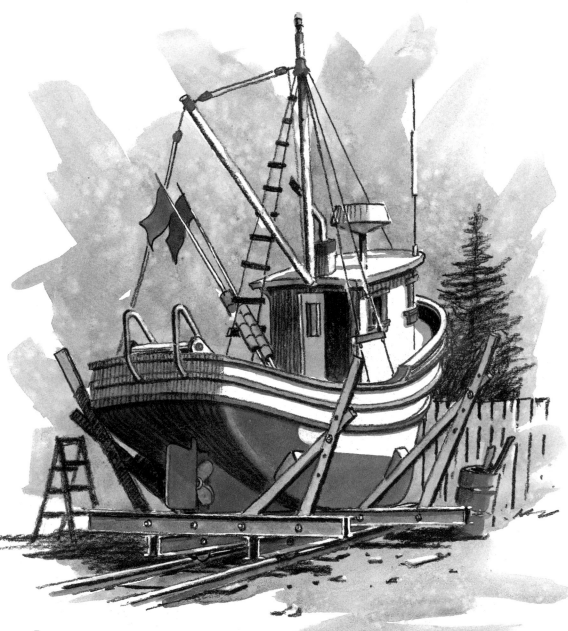

5. Finishing The Painting

Look over the painting. Does the boat look as if it's floating in the air? It needs a boat yard environment. Add shadows and rocks to show ground surface. Next, add a ladder on the left entirely in shadow. On the right paint a barrel with trash in it. Define the top of the fence by bringing a dark pine tree down against the top of it, then indicate space between the boards. Cast a shadow on the rudder and darken the screw to make it less pronounced. Now mat the painting and stand it up for review. It needs some whites for sparkle and separation to add these with an opaque white. Now the subject should be dominant. Sketching on location and seeing the area firsthand makes it possible for us to communicate the feelings we had at the time of viewing.

CHARCOAL AND WATERCOLOR
With An Acrylic Base

Another interesting approach to charcoal and watercolor can be accomplished in the following manner: (1) Lay an acrylic gesso base on cold pressed illustration board using a stiff, flat brush and random short strokes (creating texture is the goal). (2) When this has dried thoroughly, apply watercolor with a 1" flat watercolor brush (or larger). The color here is a mixture of raw sienna and ultramarine blue. Experiment with different colors for different subjects. The value is darker at the top or wherever the subject will appear.

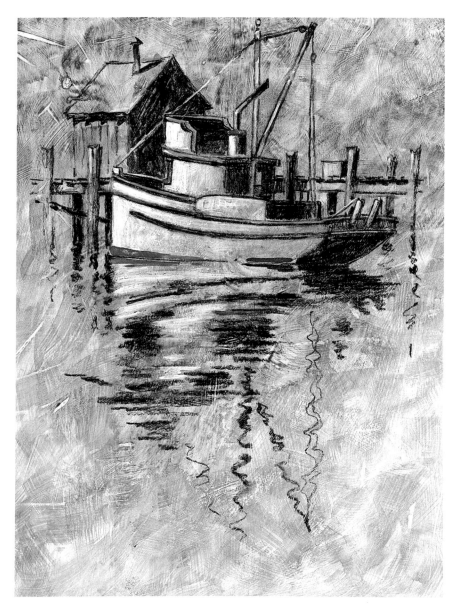

(3) The drawing is done with charcoal pencil. The arrangement and subject matter have been worked out on a separate piece of paper. It can be traced onto the illustration board if you wish. (4) The whites are water-soluble opaque white. The colors are transparent watercolors, but they can be mixed with opaque white for more brilliance. Gouache can also be used. Spray the final painting with a workable or matte fixative. It is recommended that you work on a large format for this technique. The texture possibilities are unlimited.

WATERCOLOR AND GOUACHE

Gouache extends the possibilities of change and experimental techniques. Gouache is opaque and tends to dry lighter than when it is first applied. It is very adaptable, and light colors can be painted over darker colors with brilliance. It has a different character than watercolor even though they are both water-soluble. Since gouache is opaque, it can be painted over other media quite successfully. This is what has been done in each of these demonstrations. Once in a while, you may want to put white over the shape you are working on, let it dry, and then paint color over that.

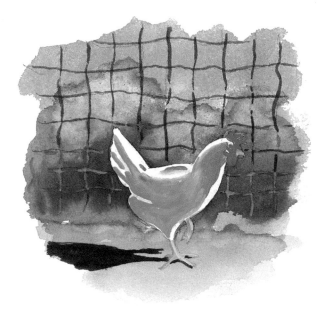

These examples are just a few ways watercolor and gouache can be combined. It is common practice to use transparent watercolor initially, finishing with gouache; but you should try various methods. As you experiment, you will enjoy the unlimited possibilities of these media.

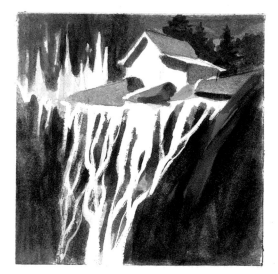

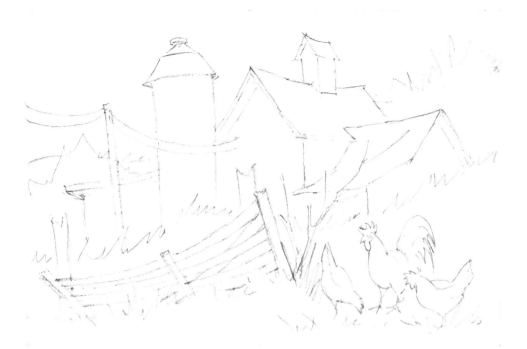

1. Barns offer unlimited combinations of shapes. The drawing is done on rough watercolor paper using an HB pencil. Indicate the location of the subjects and their approximate sizes. In this composition the fence helps to tie the elements together. The chickens will be the dominant theme and everything else is subordinate. Now is the time to analyze your drawing. You may have to paint less to tell your story. A good way to do this is to decide on the size sheet you want to work on. Try working on different sizes because each one demands a different approach. For example, a full sheet will require larger brushes for some washes and it may also require that you move faster to keep the washes flowing well. In any case, put a mat on the drawing and see if you are satisfied with the perspective, arrangement, overlapping subjects, proportions, etc. This is the time for changes. It can be changed later easier than other media as it is opaque, but planning at this time is more efficient.

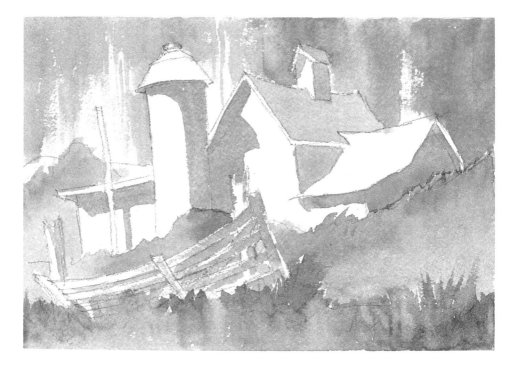

2. A conventional watercolor approach is used with the yellow ochre under the sky on the left. This is the direction of the light and the sky will be warmer here and cooler on the right. I used the cobalt blue to depict the shade and shadow on the barn. This also determines the whites in the area. The vegetation around the barn is washed in with yellow ochre and burnt sienna. The foreground is treated with cooler colors on the left corner and warmer colors on the right. This is just opposite of the sky. Keep in mind that you will add the chickens in the lower right.

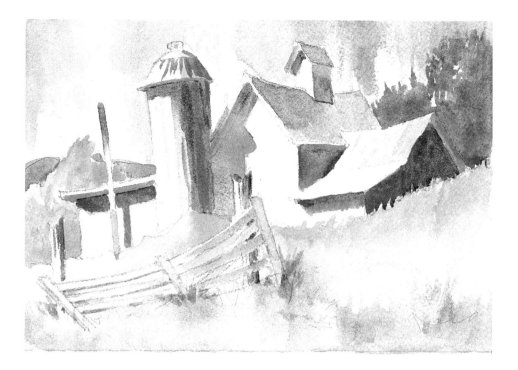

3. The transparent portion of the watercolor is complete now. The mountain and the trees on the right are completed with ultramarine blue and a little alizarin (this will keep them in the background). The shapes are added to the barn and the silo, and the shade and shadows are intensified with a bit of red floated into various areas of the shadows. More color is added to the trees on the left and to the foreground to give them some contour. The fence is completed with a grey of mixed ultramarine blue and burnt sienna. Notice that the light pole is dark only on the top and the bottom.

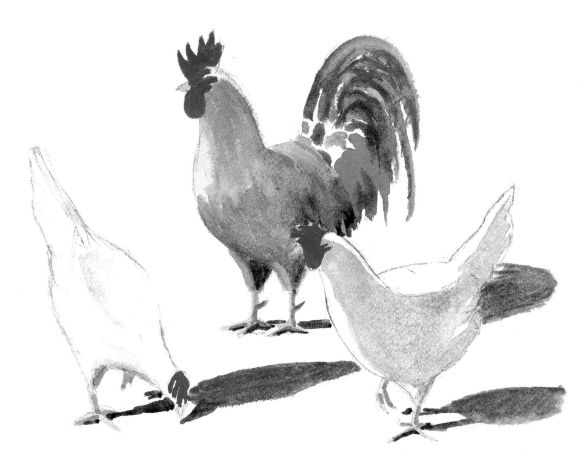

4. Know your subject. It is easy to indicate or fake something in a painting if you have studied beforehand and have done your homework. The chickens and roosters here were drawn on location at my son's ranch in Valley Center. After you have drawn something several times, you begin to know it and can paint with confidence. This applies to the barn, the fence, or any other area of the painting. Fill your sketchbook with fire hydrants, pigeons, sea gulls, telephone poles, dogs, cats and any other objects that you see. Your paintings will be richer for it. These chickens were drawn in the same arrangement as was indicated in the original sketch. The drawing and proportions are important and should be analyzed before painting. The light source must be the same as it is on the barn and fence, etc. If you work from photographs, be sure to take note of this fact, especially if working from more than one. Use the same colors as were used in the rest of the painting to create a feeling of belonging. Shape and action are important in this study as they are the only animated things in the painting and you don't want them to look stiff.

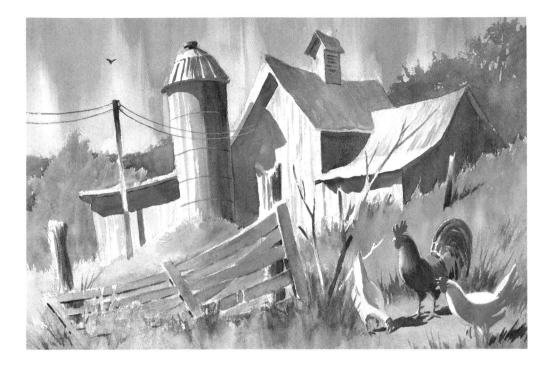

5. To add the livestock to the watercolor, sketch them right on top of the painting with an HB pencil. Another way to do this is to draw them on a piece of tracing paper, then cover the back side of the tracing paper with graphite, then transfer them to the painting (like carbon paper). Then cover the entire area within the sketch with a transparent gouache white. Dilute this with just enough water so that when it dries it will require less opaque paint or gouache to build up brilliant color. You will need to practice building up color with gouache as it can be tricky, and in some respects it is different than any other form of color. After this is dry, paint the colors according to the plan from page 39. Remember, the painting on page 40 was done on a white background. Here you are working on color, but more importantly, you are working with the surrounding colors in the painting. These must be compatible. You may have to change colors from the original plan, but not the shapes or the values. Care must be taken that the chickens and the rooster do not look pasted on. Final details are added to the barn, the fence, the fenceposts and the vegetation. Now put a mat on the painting and evaluate.

WATERCOLOR AND PEN & INK

Pen and ink has always enjoyed great popularity. It has a lot of contrast and is easy to read. Pen and ink is very expressive and gives an immediate and lasting impression. It is fun to work with and can be handled like all other media — in a number of ways. It is limited only by the imagination of the artist. Pen and ink is used in conjunction with practically every media in the visual world. It is also readily reproduced in any form, especially in newspapers. It was exploited by the great illustrators of the past as it was their only medium for many years until color separation came into practical use. At first, only single color washes were used in conjunction with pen and ink, but as the printing industry's ability to reproduce color increased, so did the artist's imagination. Many of the great illustrations for books and advertisements were done with this combination of media. It became more and more refined and was used by many fine artists in both representational and abstract styles. Today, entire books are written exploring the possibilities of pen and ink, watercolor and other media. You will be rewarded for having india ink in your studio.

This was done on illustration board with a cold press surface. Before inking in the sketch, draw it loosely with pencil. Or, if you practice often, you may feel more confident with a direct pen and ink approach. Ink is not easily removed, so experience is important. Be sure to give consideration to what you want to say and concentrate on shapes and proportions as they can not be changed after you begin. When the drawing of shapes, the arrange ment and the proportions are as you want them, think about washing it in. The light source is usually determined in the pen and ink stage. The shadows to be painted over are indicated here. They should be painted over with cool, dark color. Decide on the color, then wash it in with watercolor, keeping the same light source in mind. In this case, light and warm on the left, and cool and dark on the right.

In a very detailed sketch such as the wagon, do a line drawing with pencil first. This can be done from a previous sketch, on location or from a photo. Pay attention to the proportion, shapes and shade and shadow. The pen and ink technique can be handled a number of ways, this is just one. Transparent watercolor works well on this board. Use warm on the light side, and cool in the shade and shadow. Add some local color in the metal and you have a finished colored drawing.

Old western towns make great subject matter. This old false front building is used to demonstrate a more casual pen and ink approach. The values are established in the drawing and reinforced in the pen and ink work. Try to use some form of line work or cross-hatching in the shade and shadow area so the color will show through even in the darkest areas. Local color is considered when applying the watercolor. A strong feeling of sunlight is felt because of the warm and cool colors. The lights and darks (values) are created by the ink drawing underneath.

It is a good idea to try many subjects in all media that you choose. Mechanical things such as machinery, buildings, vehicles, etc., come easy to me as I have an illustrator's background and am well grounded in perspective; but nature is a different matter and takes more effort. For one thing, animals don't hold still. I do many sketches and take many photographs. Most wildlife artists work this way. We have the plus of taking detailed photographs, but sketching is still a wonderful way to become acquainted with wildlife — their characters and their habitats. Many of the great painters live with their subjects for long periods of time. Arrangement becomes even more critical because when the subject is placed correctly in a photo, then everything else is wrong and vice versa. Drawing the subject above requires time and practice. Sketch, sketch, sketch!

1. There are many basic principles involved with still life. As a learning exercise in the classroom, still life is outstanding. It is limitless as far as materials, arrangement, technique, medium and satisfaction are concerned. The challenge of assembling the material itself is worth the exercise. Here are a number of things found in a fisherman's shack on the east coast. They were selected because of their different materials and shapes and the ability to arrange and portray them in an interesting way. The drawing is done with HB pencil on a rough illustration board. Some attention must be given to detail at this time. The most important things as far as the subjects are concerned are the arrangement (composition involving shapes) and proportions. Relationships to one another must also be accomplished at this time. Overlapping one subject over another is important in preventing objects from "floating" by themselves and also helps to communicate better. Evaluating the drawing with a mat is very important at this stage since pen and ink is difficult to change. Look at your drawing carefully. It is better to make changes or to start over now than to wish you had when the painting is complete.

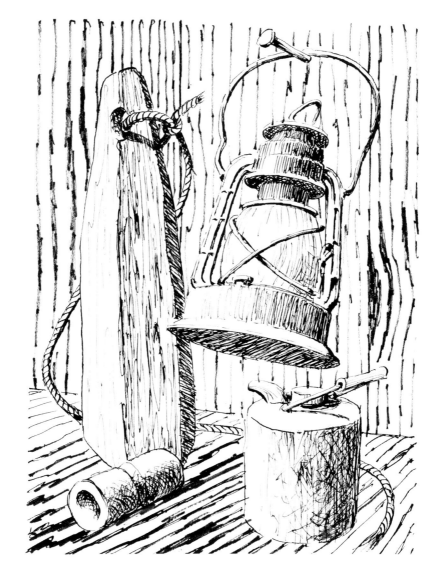

2. The challenge here is to show shape (value) by choosing a technique that allows great flexibility. Try to show that each of these subjects is made out of a different material. With a light source coming from upper left, depict a light value, a medium value and a dark value using different strokes to create different materials. Everything in this drawing seems to be of equal importance, including the back-ground. Now is the time to evaluate the drawing again. The color will enhance the drawing and allow for some things to be dominant while others are subordinate. It will not, however, change the basic values. The lights and darks are set at this stage. The ever-important shadows need to be recorded (if we are working from a real set-up) for the shapes that hold things together.

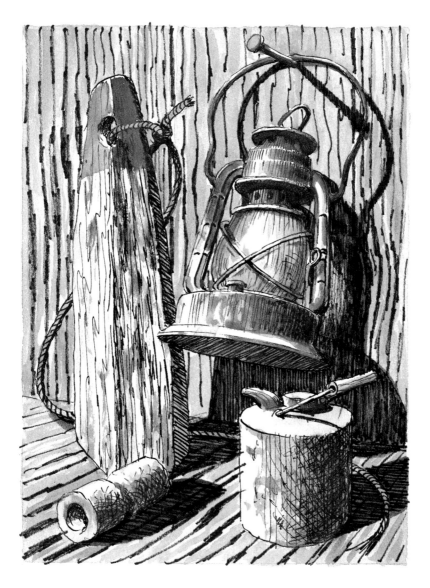

3. Wash in the floor with a warm gray, and add the wall in the background with a cooler gray. The shadows are important to this work, so after the watercolor has dried, sketch them in with pencil. (They will be impossible to change later.) When inking the shadows use strokes that will indicate the surface they are falling on, perpendicular with the perspective down below and vertical on the wall. The marker, or buoy, on the left is wood with a peeling paint surface, so try to add some of the gray from the wall and the floor to it. The lantern is rusty, but the glass still has a shine. The fuel bucket is a gray tin with dents and rust spots and the line guide is cork. The line is hemp and should be related to the cork. Now put the mat on the drawing again and make a few last minute adjustments. The colors used in this work are: raw sienna, burnt sienna, cadmium red medium, alizarin crimson, ultramarine blue and thalo blue. Practice mixing grays as they are the element that holds a painting together. Not everything can be bright or intense color. All of the whites here are the paper, but an opaque white can also be used and is the only way you can introduce whites at this stage. An electric eraser can be attempted, but india ink is very permanent. I hope you enjoy this way of working as much as I do.

WATERCOLOR AND COLLAGE

Collage means to paste paper to a surface. If any technique has ever offered unlimited possibilities, the combination of watercolor and collage is it. Picasso and Braque began adding collage materials to their paintings almost 80 years ago, and a steady parade of talented, creative people have continued to pursue this challenge. Collage can be combined with almost any painting medium or it can be used alone with no paint at all. It can be done on almost any surface, and wood, plastic and metal have been adhered to the surfaces. Collage is more than a gimmick, a technique or a way to "save" a watercolor or other medium. It is a process that enables you to evaluate and learn about constructing a painting. Basic thinking doesn't change; concept, composition, values and color relationships must still be determined. However, collage can help you to change direction or dominance in a painting.

Through experimentation, it can help you to express yourself in a personal and effective way. In collage more than any other media, you must explore, experiment and move ahead on a trial and error basis.

In the following project we will glue papers to a watercolor surface to provide textured areas on which to paint. On the right is an assortment of rice papers. We are mostly concerned about texture and transparency. These are adhered to a watercolor surface with one of the adhesives below. Many types of pastes or glues will work, but they must work with water-based materials. White pVA/polyvinyl acetate glue, acrylic matte medium and gesso are shown here. The white glue works best. One important factor is that the material used to glue the rice papers onto the paper must leave a surface that will accept watercolor.

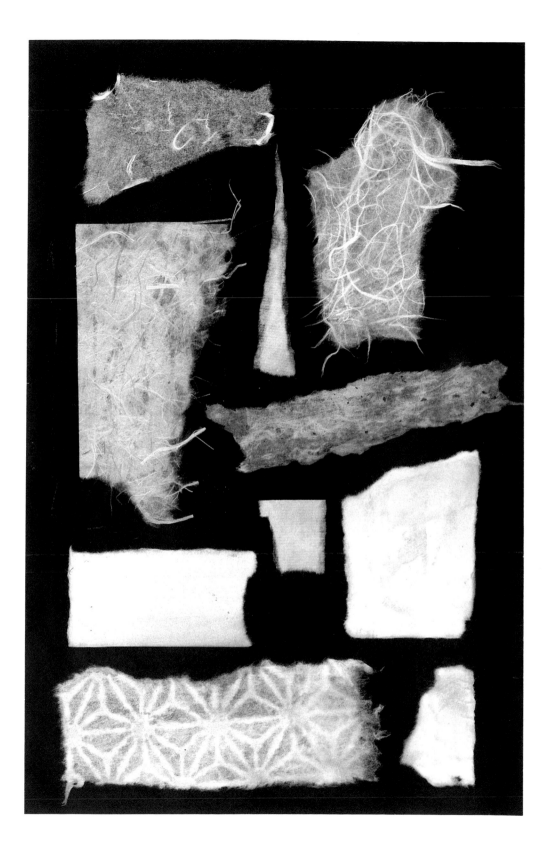

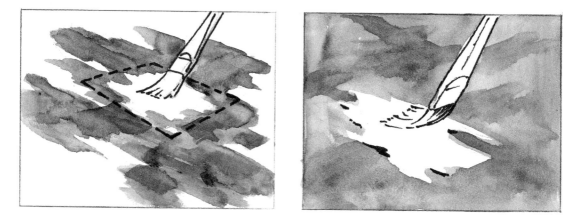

First paint the surface with transparent watercolor, preferably in some form of design. Then mix some glue with water until it is the consistency of cream. Using a large brush, spread this mixture onto the surface in any area larger than the piece of torn oriental paper. Position the paper in the wet glue, then brush over it with the brush (do not add more glue). Keep adding pieces of paper until you have covered as much of the surface as you wish to change or to work on.

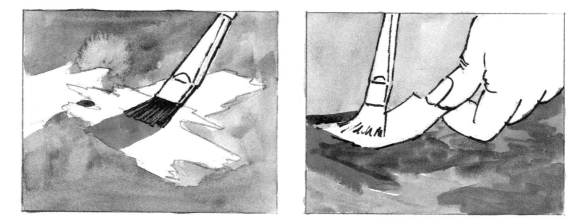

When the glue is dry, use a flat watercolor brush to add some color. After putting the brush into the water and then into the paint, lightly wipe it off on a paper towel for a dry brush approach. If the value becomes too dark or you wish to change your direction or design, parts of the painting can be collaged again which will introduce a lighter value and a new area to paint on. Practice applying color over the collage until you are confident you can achieve the value and intensity you desire.

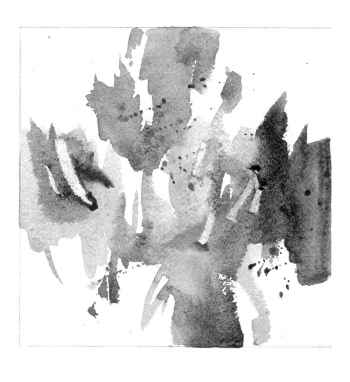

The basic design is a cruciform on a 7 inch square piece of 300 lb. rough watercolor paper. The colors used are raw sienna, burnt sienna and burnt umber — analogous colors for simple harmony. This is a very casual design with some paint spatter and a few scratches from the wedge end of a 1″ flat brush. It is an indication or a beginning for our texture. The thrust is vertical, from right to left.

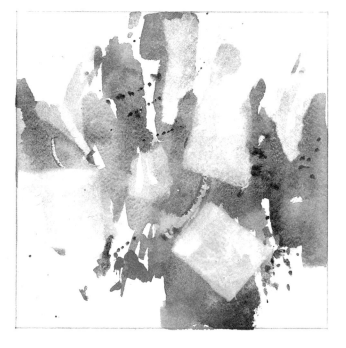

Begin to add some pieces of oriental paper. The papers are different in texture and transparency and each one is in a different torn shape. They are added to find a new, exciting design. Glue these down with white glue. Here some of the more opaque papers are used so you can see how they are arranged. You are trying to add texture and change the original design, while at the same time following any suggestions or indications you acquire from the collaged area.

Here additional rice papers have been layered on the painting. Now they are overlapping with the more opaque papers in certain places, often suggesting design possibilities. When the glue is thoroughly dry, try adding some watercolor to this new surface. Use a dry brush technique and the colors will be more brilliant and the texture will be enhanced. Patterns will also change. Use the same colors you started with or colors in the same harmony. The visual movement is changing vertically from the bottom to the upper right. If there are any loose edges, scrape them off with a razor blade.

Add darker washes, but continue to preserve the color dominance. Key the shapes to existing shapes and fibers. Follow lines and edges that seem to exist. Concentrate the visual activity near the center. Add dark area accents and strengthen contrasts. Add some cool areas to give more visual contrast, and to relieve the warm dominance enough to satisfy. For the purpose of demonstration, rice paper is used here with exaggerated texture because reducing the painting for this book makes it difficult to see the subtle changes.

Continue changing the thrust from the bottom toward the upper right by adding a few more pieces of rice paper to the upper right. Intensify the burnt sienna in the central area and slightly off to the left for balance. Additional blue (manganese and cobalt) is needed to cool and balance the warms. If the direction left to right from the bottom is moving a little too fast, add some lines to counter this and for additional interest. Add some paint spatter for the same purpose. All of these things are personal taste; they are exaggerated here in an effort to encourage you to experiment with this technique. How much to collage and how much to leave original washes will come with continued practice. Exercises like this will help you to review the basics as you search for value, color and shapes that please you.

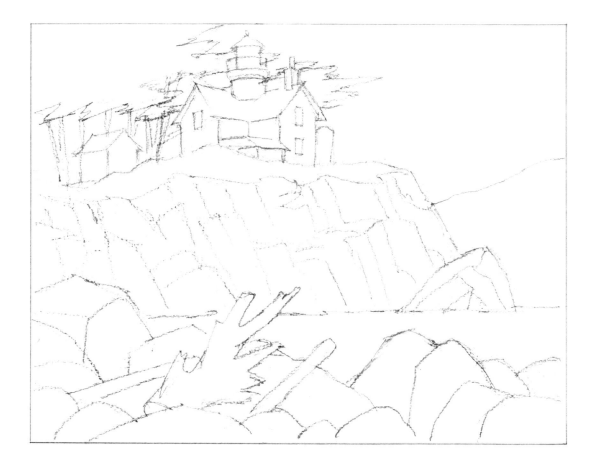

1. The pencil drawing was done with an HB pencil on 300 lb. watercolor paper. It was done from a sketch and from photographs taken on location in Cresent City, California. The lighthouse and the foreground have been simplified for this demonstration. The rocks and the driftwood in the foreground are enlarged to bring them forward and they are drawn dark enough to see their shapes through the first washes. The lighthouse in the upper left is in a good location visually and is easy to dramatize. One of the wonderful things about collage is that you can change your mind at the last minute and make the foreground dominant and the lighthouse subordinate. With this technique you can keep these options open longer than with any other media.

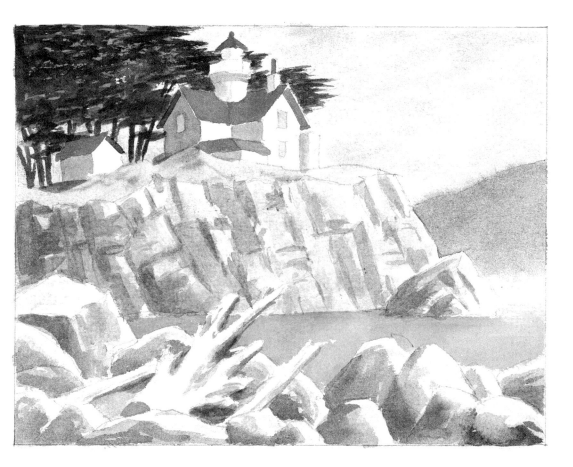

2. The watercolor is painted with basic colors first. The gray sky provides a late-in-the-day mood, and the white on the lighthouse gives a little lingering sunlight. The trees are painted with a basic cool green and allowed to dry. The dark green is painted over with horizontal strokes, leaving some of the original wash showing through for texture. Now the shapes and the colors on the lighthouse and the other buildings are established. The grass is painted with a warm green and some cools to indicate shape. The grass and the sky will not be collaged. Basic shapes are shown in the rocks below the lighthouse. More definite shapes are shown in the foreground rocks and the driftwood as this is the area to be collaged.

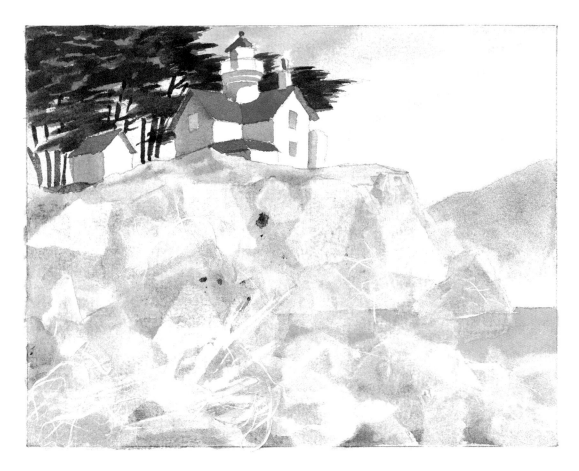

3. The collage is added to the foreground and progresses back and up to the lawn of the lighthouse, slightly overlapping the lawn and the mountains on the right. These papers have already covered much of the original washes and shapes. They suggest new shapes, patterns and textures. While you can still see some original outline, it is a good time to decide if this is the best way to go or if a better composition is possible. This is an exciting stage of collage because you have unlimited options on the lower two-thirds of the painting. This doesn't mean that you can't collage the remainder of the painting if you wish to make even more changes.

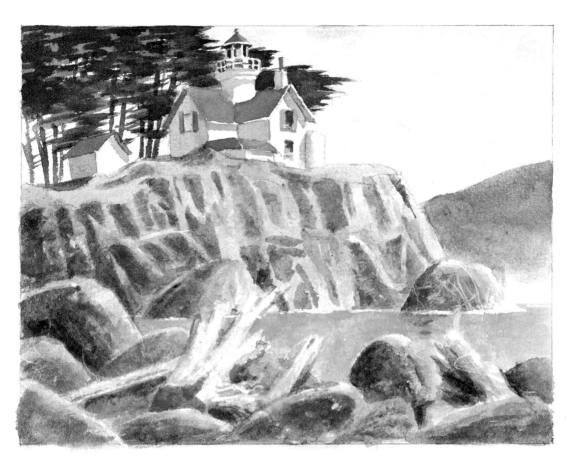

4. Paint in the foreground first, then work back and up. There are new shapes and textures here. Some are in focus; some are a little vague and left to the imagination. Add some of the green from the grass to the rocks in the foreground. Increase the darks in the foreground and especially to the left as you want the viewer to look to the left and up into the painting. The collage material suggests all new shapes for the rock wall and for the rocks on the right. Paint the mountain back over the collage material and up to the wall (the shapes are different than in the original watercolor). Intensify some of the green in the foreground rocks over the collage material to create a good visual transition. Now put a mat on the painting and add detail to the lighthouse. Most of the whites in the lighthouse are from the original watercolor paper. The fine detailing in the railing is done with opaque white.

GALLERY

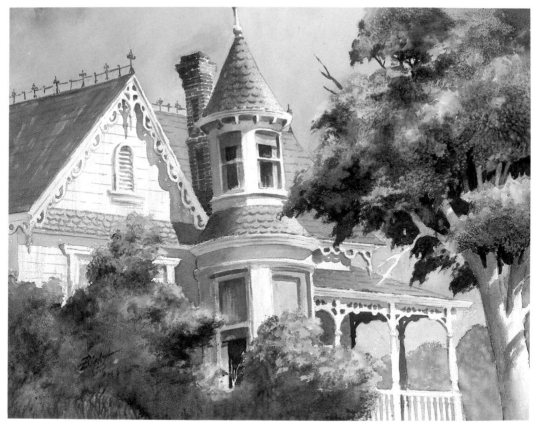

Victorian/Eureka Springs
by Duane R. Light
Watercolor and Gouache
21″ x 28″
Collection: The Artist

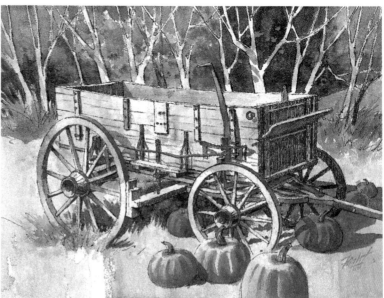

Midwestern Fall
by Duane R. Light
Felt Pen and Watercolor
18″ x 24″
Collection: The Artist

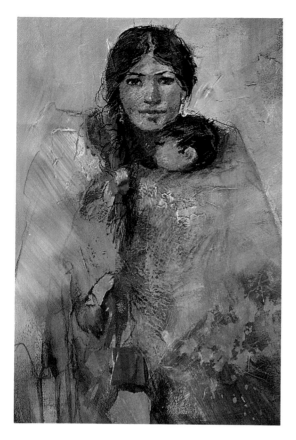

Mother and Babe
by Pauline Doblado
Watercolor, Collage and Pastel
30" x 22"
Collection: The Artist

The color and the rich texture in this outstanding painting of a mother and child show how the artist retained control by handling her materials with skill and great care.

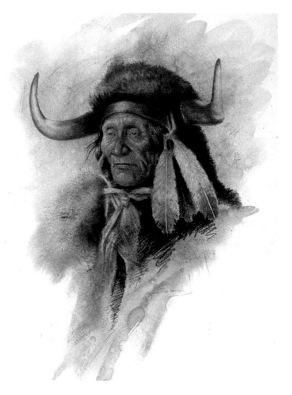

Buffalo Man by Bob Garner
Watercolor and Charcoal
28" x 36"
Private Collection

The effect achieved by the artist through the use of watercolor, powdered charcoal, charcoal stick and charcoal pencil shows the result of capable drawing and perseverance in developing a technique.

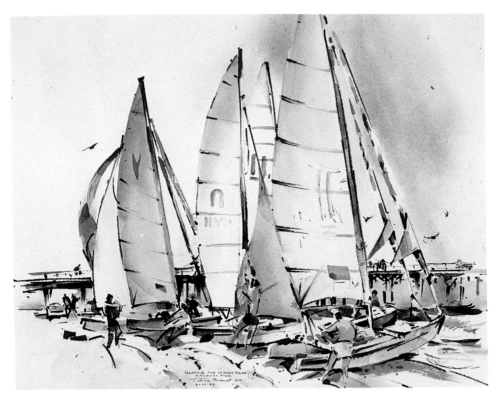

LeMans Start by Rex Brandt, N.A. A.W.A.
Felt Pen and Watercolor
18″ x 22″
Private Collection

As you can see, the handling of these mixed media in the hands of a master allows a casual approach, yet achieves feel and excitement because of intimate knowledge of the subject.

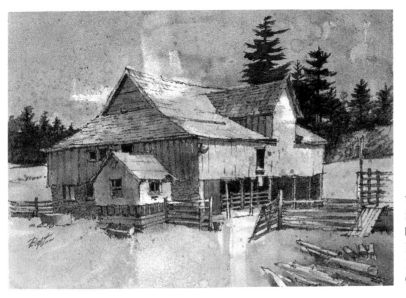

**Weather Breaking/
San Juan Island**
by Duane R. Light
Felt Pen and Watercolor
18″ x 24″
Collection: The Artist

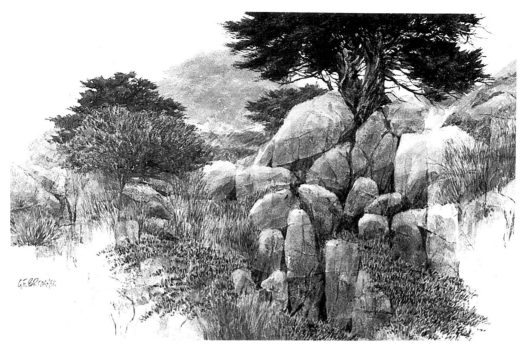

Carmel Motif by Jerry Brommer
Collage and Watercolor
22″ x 30″
Private Collection

You could say that Jerry "wrote the book" on collage and it shows in his teaching and his outstanding handling of the media in all of his work. The transition from collage to that which is not collage is the result of searching for the ultimate in the final painting.

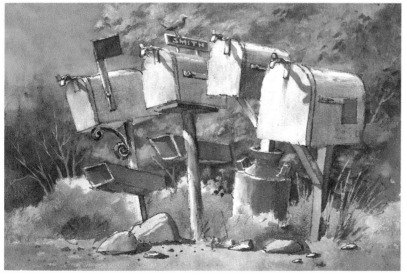

Mailman Cometh
by Duane R. Light
Watercolor, Gouache
and Felt Pen
20″ x 26″
Collection: The Artist

Smooth Evening/Bodego Bay
by Duane R. Light
Charcoal and Watercolor
19″ x 26″
Collection: The Artist

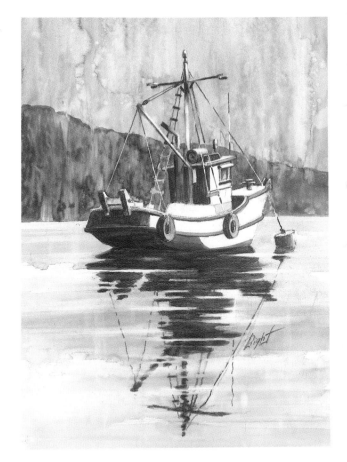

Brandt's Rock, Corona Del Mar by Duane R. Light
Felt Pen, Watercolor and Gouache 14″ x 20″
Collection: The Artist

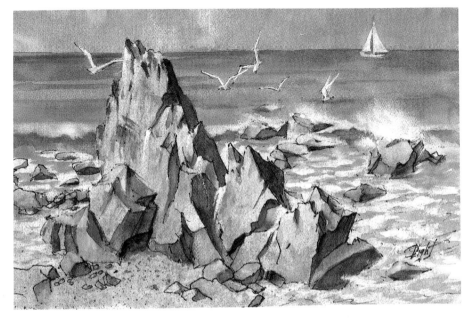